Reality is a concept that depends largely upon where you point your face.

Other Books by Demetri Martin

This Is a Book

Point Your Face At This

DRAWINGS

by

Demetri Martin

GRAND CENTRAL
PUBLISHING

NEW YORK BOSTON

Grand Central Publishing
Hachette Book Group
1290 Avenue of the Americas
New York, NY 10104

HachetteBookGroup.com

Printed in the United States of America

LSC-C

First Edition: March 2013

10 9 8 7 6 5

Grand Central Publishing is a division of Hachette Book Group, Inc.
The Grand Central Publishing name and logo is a trademark of Hachette Book Group, Inc.

The Hachette Speakers Bureau provides a wide range of authors for speaking events. To find out more, go to www.hachettespeakersbureau.com or call (866) 376-6591.

The publisher is not responsible for websites (or their content) that are not owned by the publisher.

Library of Congress Control Number: 2012952133

Preview of Some of the Lines
and Shapes used in this Book

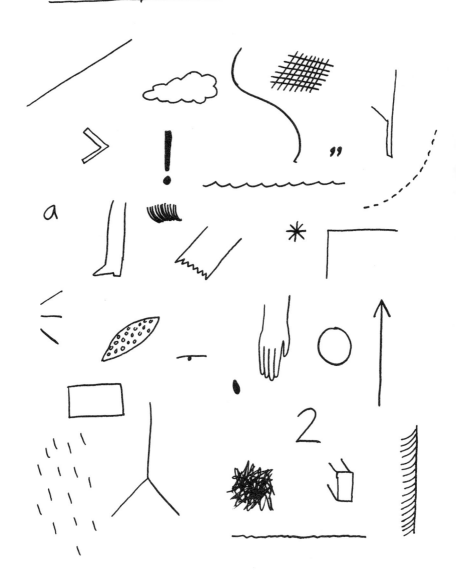

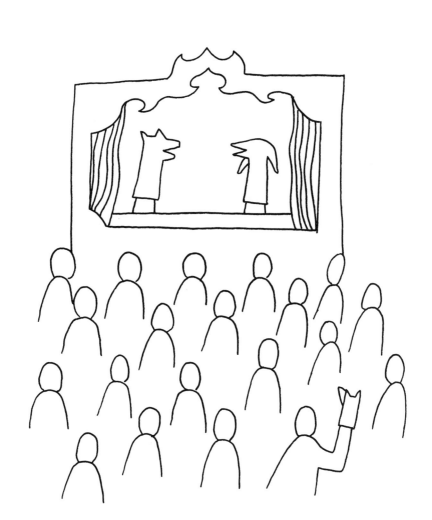

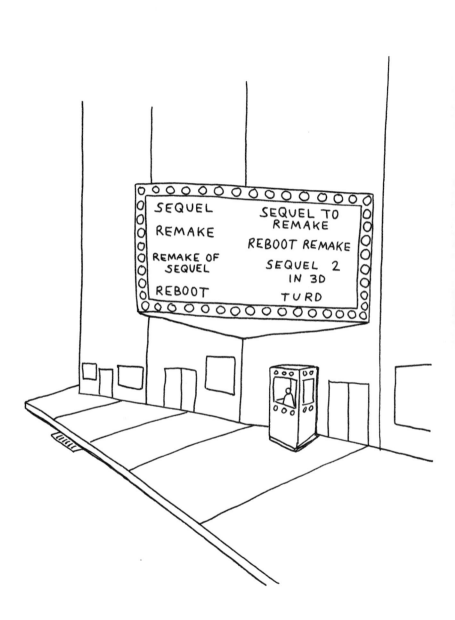

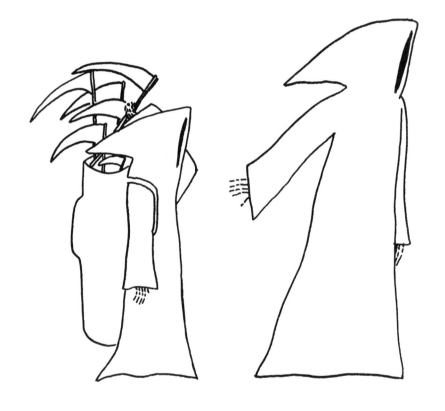

Place	Time	=
Right	Right	Successful
Right	Wrong	Frustrated
Wrong	Right	Lost
Wrong	Wrong	Dead

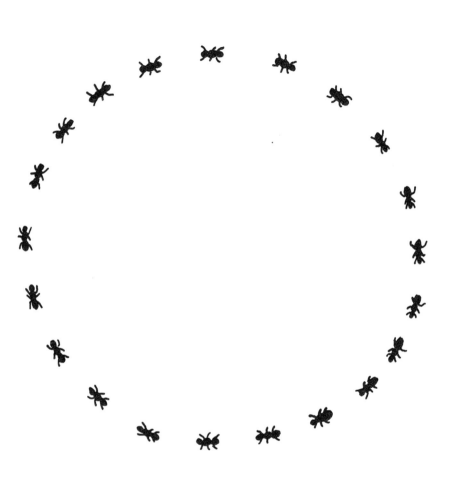

Unproductive Ants

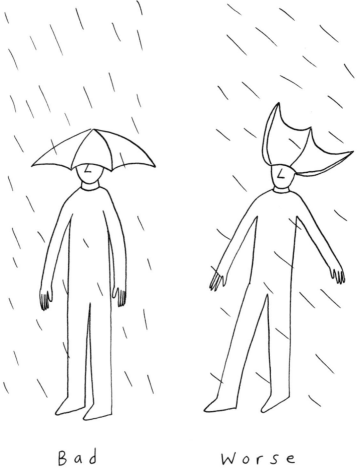

Bad Worse

Lion Tamer

Q: Why do the lions need to be tamed?

A: Well, um--

Q: They don't need to be. Right?

A: No. Yes, I mean--

Q: Are they tamed just so that you can have a job?

A: What are you trying to say?

Q: Just answer the question please.

A: I don't like your tone.

Q: Why don't you leave the lions alone?

A: (Gets up and walks away)

 -- unlatching sound --

Q: Uh oh.

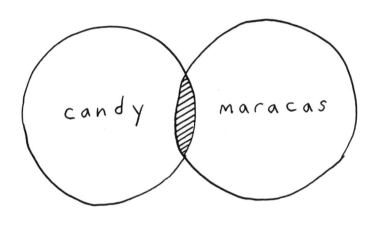

candy maracas

 = Tic Tacs

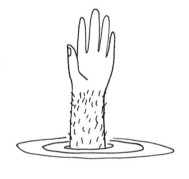

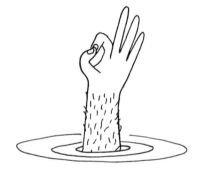

"I'm drowning" "I'm okay"

Portrait of short man

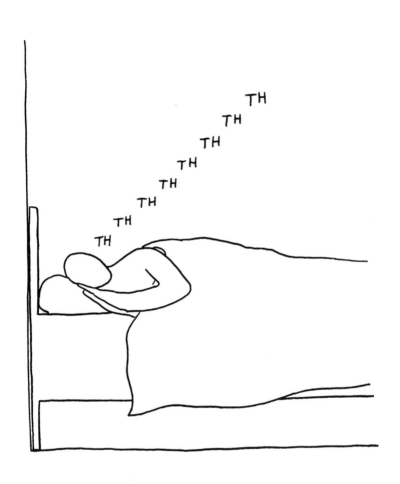

Man with lisp sleeping

Existence

Life — Death — Afterlife — After Party

"I've got a plan."

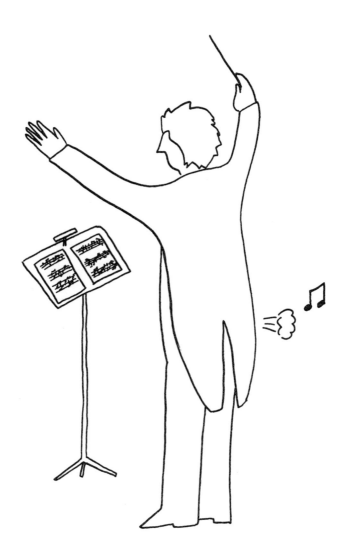

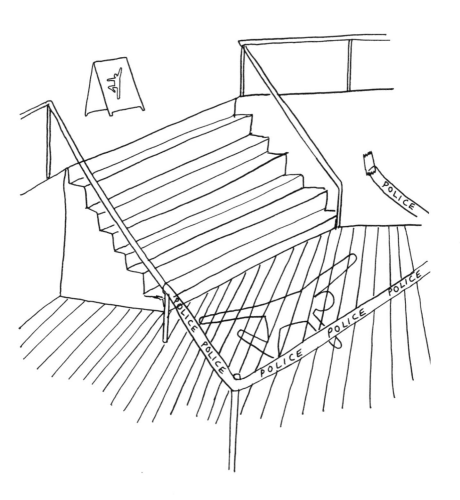

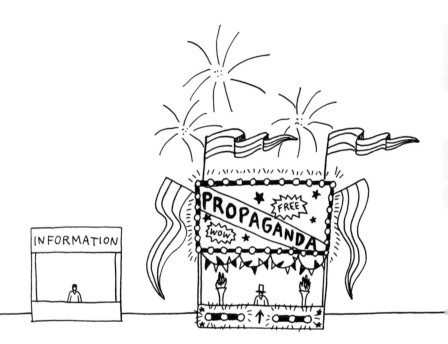

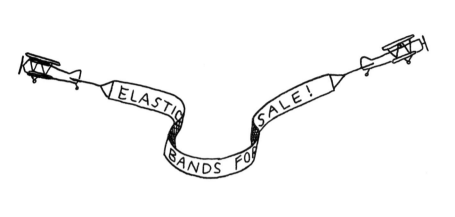

Actual A-hole

Books

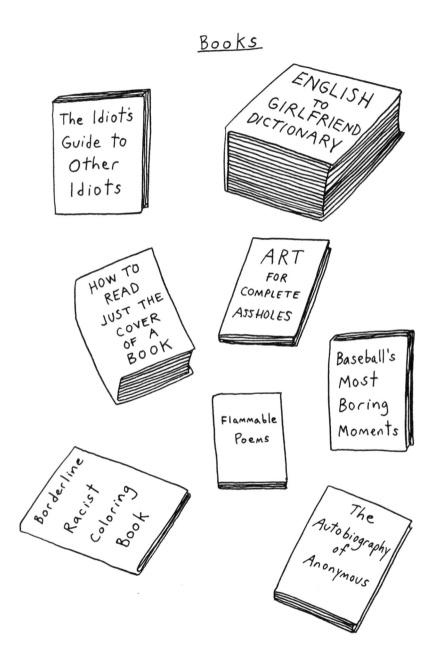

When There Is No Napkin

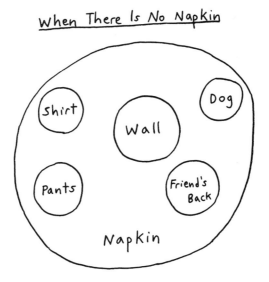

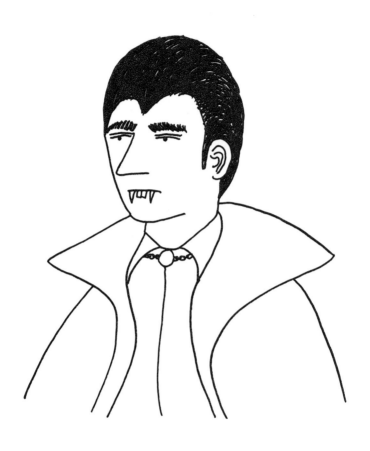

Bucktooth Vampire
(Rare)

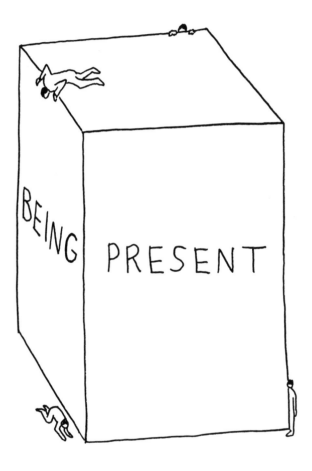

TO DO

☐ TA DA

Magician's To Do List

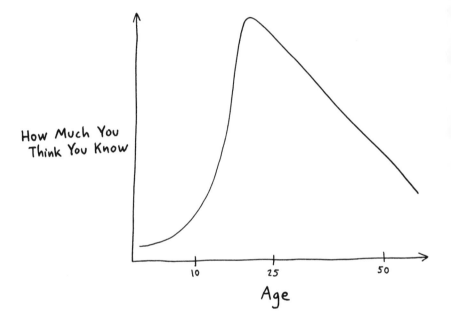

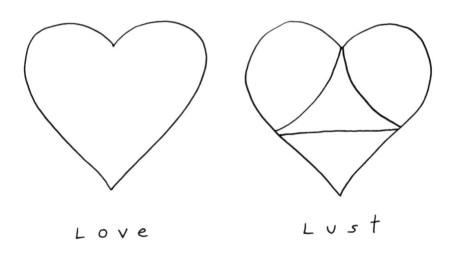

Love Lust

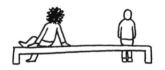

Mustaches

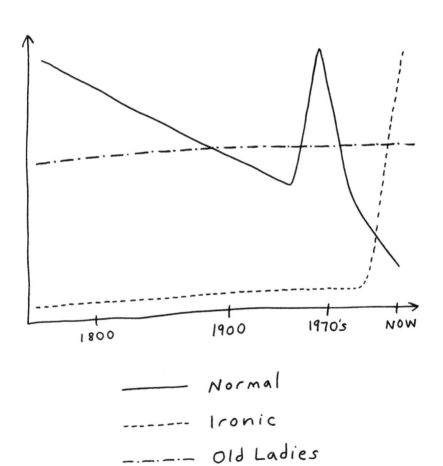

Buried at Sea > Buried at Pond

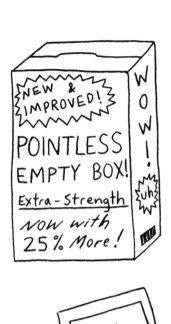

NEW &
IMPROVED!

WOW! uh

POINTLESS
EMPTY BOX!

Extra-Strength

now with
25% More!

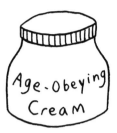

Age-Obeying
Cream

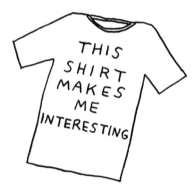

THIS
SHIRT
MAKES
ME
INTERESTING

THE PAST

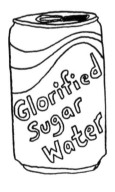

Glorified
Sugar
Water

ROUND
$
THING

SOMEONE
ELSE

IMPAIRED
LITE
JUDGMENT

GO
IDIOTS

CONGRATS
and also I am
envious of your
achievement

PILLS
PILLS
INSANE
STRENGTH
!
o

INSURMOUNTABLE
STUDENT
LOANS

FUN
KID DRINK
90%
REAL
CHEMICALS
YUM!

"I hate you, but I'm not <u>in</u> hate with you."

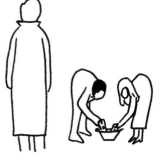

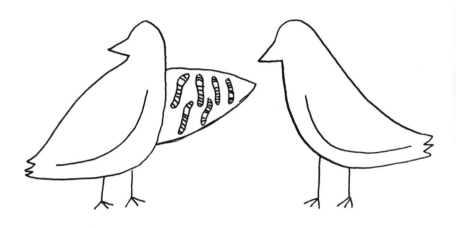

A tip: Failed
B tip: Failed
C tip: Failed
D tip: Failed
E tip: Failed
F tip: Failed
G tip: Failed
H tip: Failed
I tip: Failed
J tip: Failed
K tip: Failed
L tip: Failed
M tip: Failed
N tip: Failed
O tip: Failed
P tip: Failed
Q tip: Good

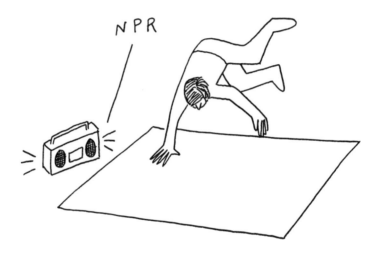

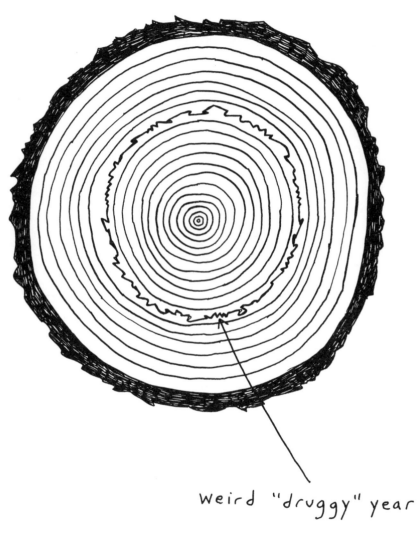

weird "druggy" year

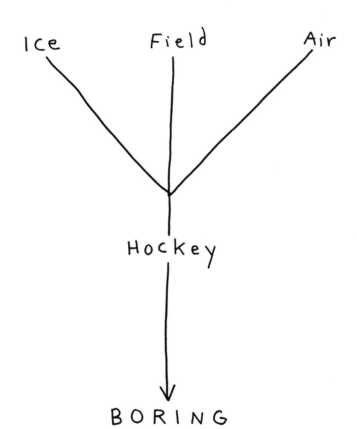

Fork vs. Cherry Tomato

Fork: 0

Cherry Tomato: 3

TV

Buy things, Stupid!

Internet

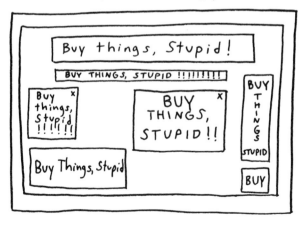

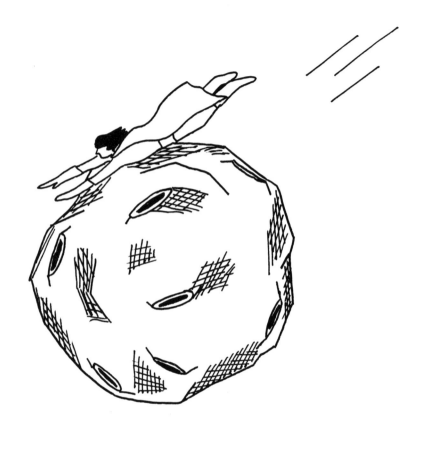

Hero "flies" using meteor
(Lazy)

Design: Surprise Birthday Candle

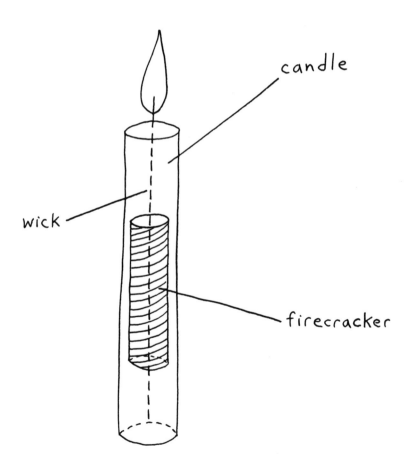

candle

wick

firecracker

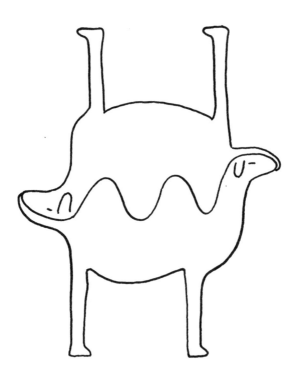

God's Camel Mold

Maybe if I talk about all of the things that I have accomplished and my education and how much I've travelled and if I do my best to show off my knowledge and at the same time express interest in her but also come across aloof so that I can be both accessible and mysterious in an effortless way that communicates confidence and vulnerability and projects a sense of maturity but not without a sense of humor because I should be funny, which is not to say

I'm hot.

Level of Interest

D&D Q&A S&M R&R m&m T&A

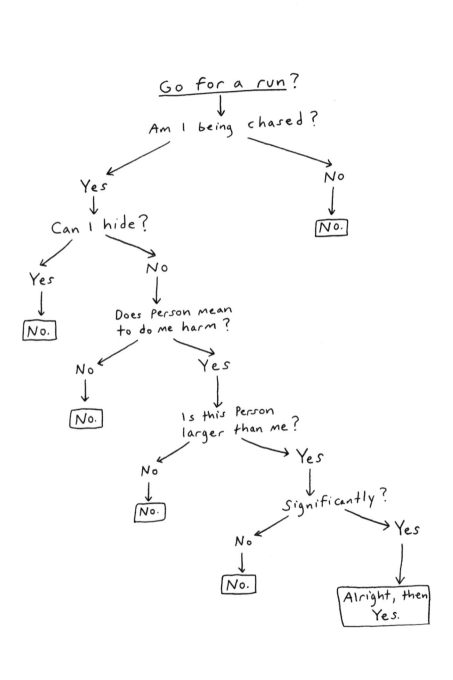

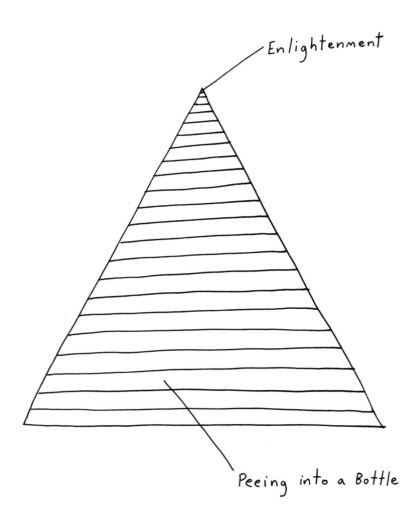

NY: $ → ☆

LA: ☆ → $

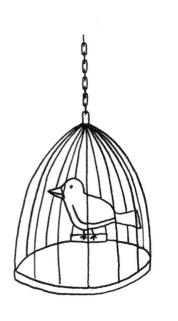

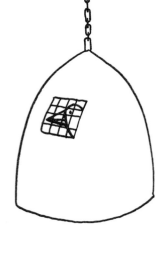

Pet Bird

Pet Psycho
Bird

Polygamist

"I think we should see other people."

Pirate

Married Pirate

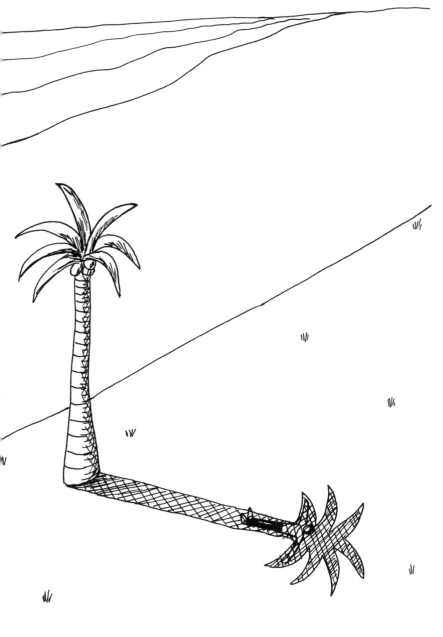

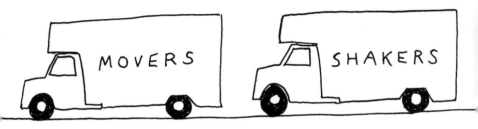

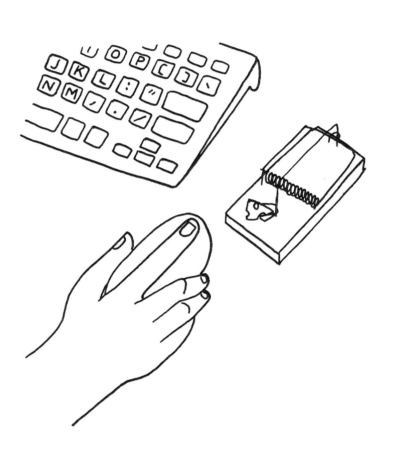

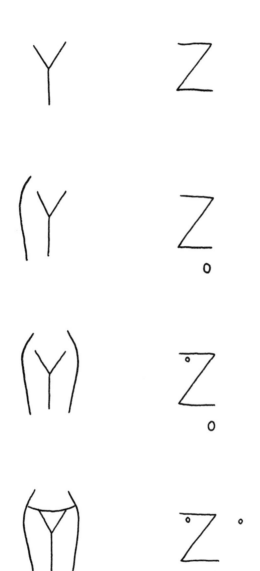

PIE CHART

Please Never Do This

Cow \longrightarrow Beef

Pig \longrightarrow Pork

Sheep \longrightarrow Mutton

Deer \longrightarrow Venison

Chicken \longrightarrow Chicken

Turkey \longrightarrow Turkey

Duck \longrightarrow Duck

<u>Rule</u>: Birds don't get to
have a new "name".
(only mammals do)

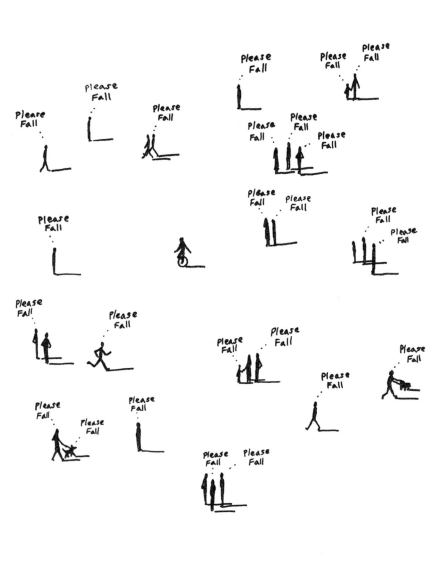

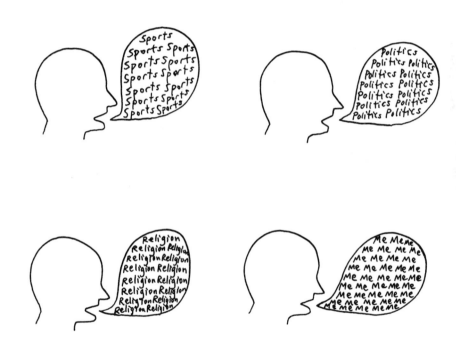

The single woman's choices

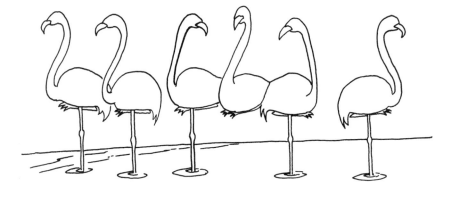

This is most acceptable when it is thrower's baby and thrower is not angry or drunk.

z e b r a
(rearranged)

Moments before he was asked to leave the team-building exercise

"Folks, this is your captain speaking. Please fasten your seatbelts securely around your waist. My wife left me this morning and now I'm going to need to vent a little."

—— Social Media

----- Compassion

My waist size*

* Damn

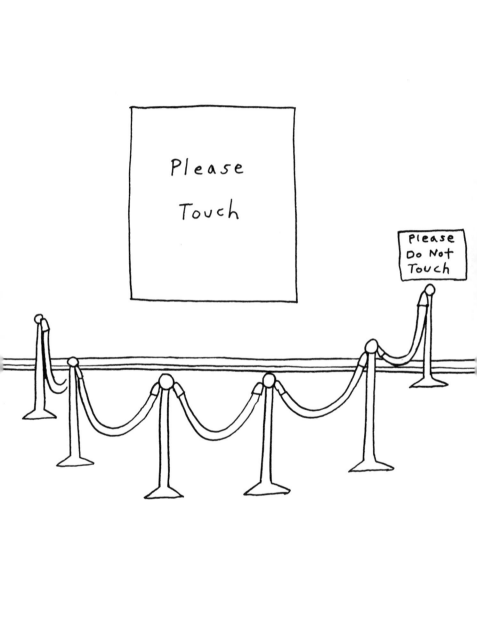

Numbers

3 Number of notes of ringtone I need to hear to know person is a tool

96 Awkward position in bed

9 Good nickname for woodshop teacher

0000000 Trying to get a representative on a phone call

7 Number most likely to come back to you if you throw it

-2 sex change

> 1,000,000,000 Supposed number of breakups that were "mutual"

< 100 Actual number that were

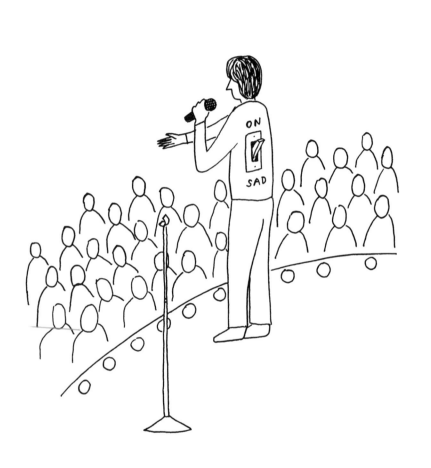

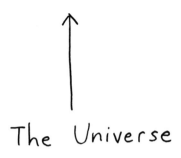

The Universe

You

Bag Types | After Being Barfed Into

Hand Bag

Barf Bag

Shopping Bag

Barf Bag

Gym Bag

Barf Bag

Tote Bag

Barf Bag

Barf Bag

Barf Bag

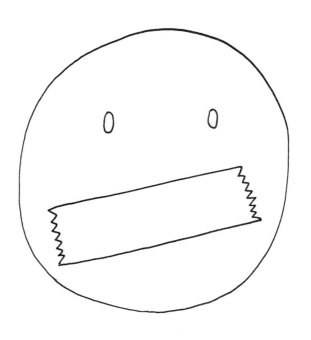

Have a quiet day.

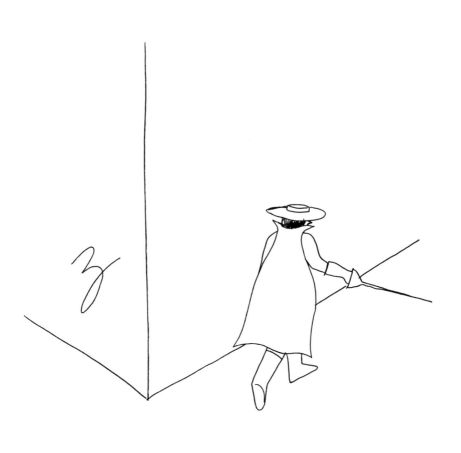

Zorro during his
cursive phase

Polka Dots
(side view)

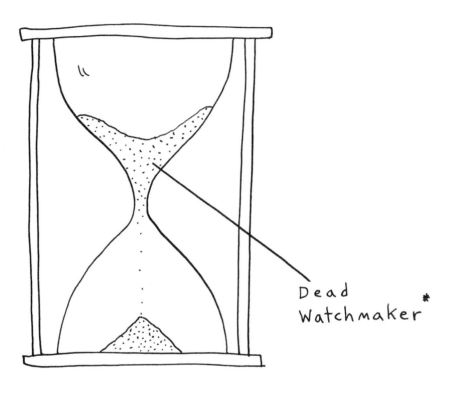

Dead
Watchmaker*

* cremated

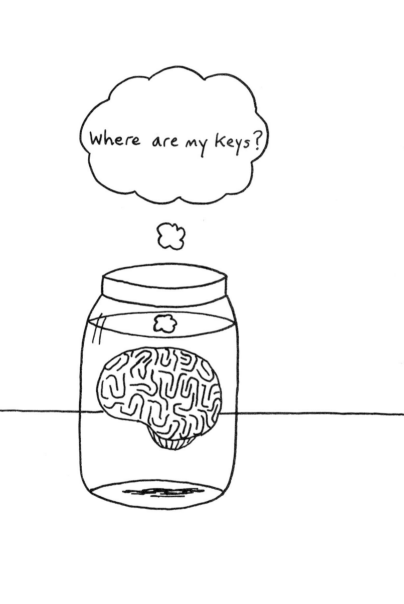

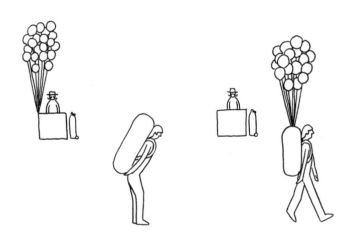

All fish are skinny dipping*

*does not include shellfish

Mosquito Light

Paranoid Regular

Dry Hump

Hippie Feminine Sans Serif

Gravity Bold

Bumper Stickers

Embarrassed child of
Proud Parent of
Honor student

VERY DUMB.

A Quick, Easy !
way to hate me!

Jesus Likes
You As a Friend.

Cliché that I
think is original

My other car is also
owned by an annoying
idiot.

Crap. I can't remove this.

God Is My Flight Attendant

My Boring Opinion -

Pro - the opposite of
whatever you believe about Abortion

TBD!

someone
died

no one
died

flagpole
operator
died

Suggestions for Sports

Volleyball Make one player on each side wear a blindfold

Diving Each diver must meet minimum weight requirement (very heavy)

Football Make outfits look gayer (if that's even possible)

Bowling Bowlers have grippier bowling balls — so that sometimes they end up throwing themselves with ball.

Figure skating & Hockey Switch Outfits

Horse Racing Remove Horses (Jockey Sprints)

Soccer I don't know what to tell you

0 1 2 3 4 5 6

0
2 3 2 /
H 2 5

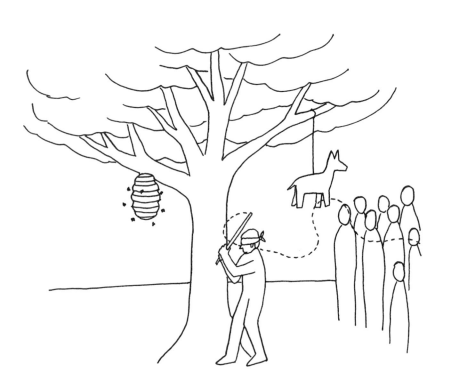

For some reason clouds
don't go this way

Bored aboard a bored board

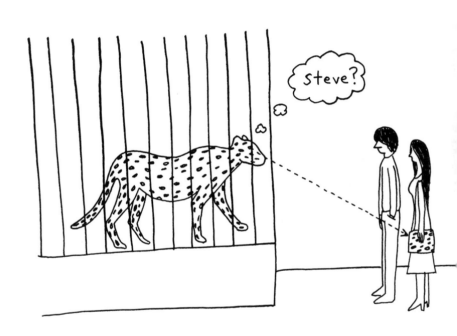

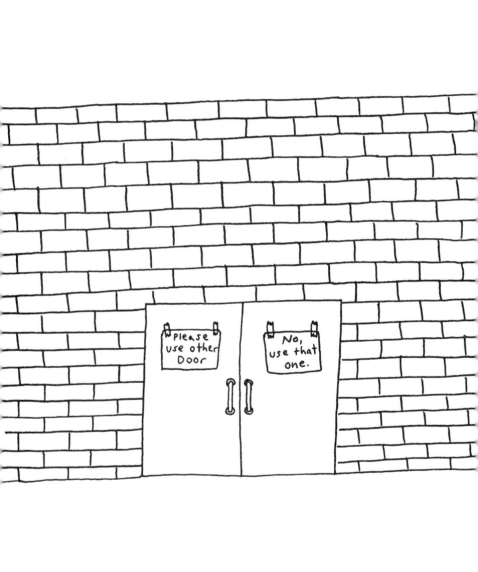

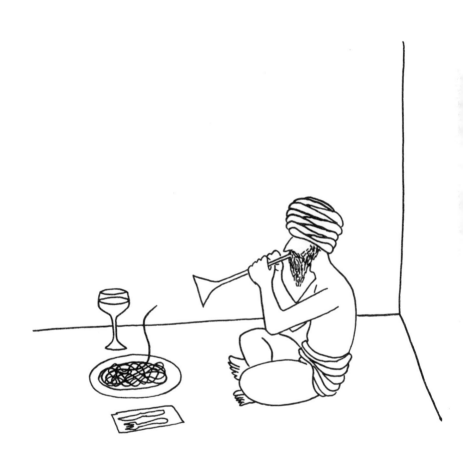

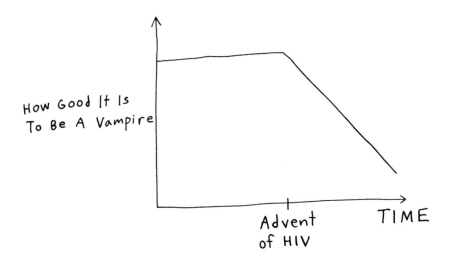

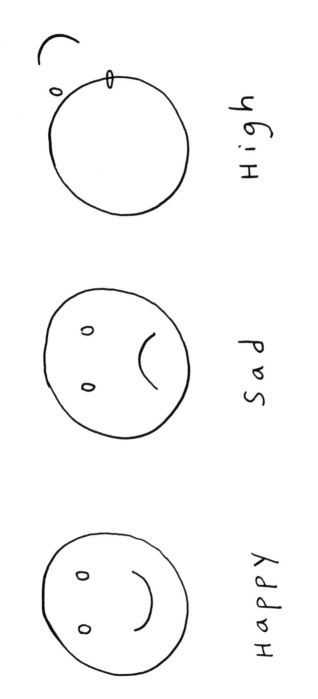

Happy

Sad

High

HOLIDAY	SUCKS FOR
Halloween	Pumpkins
Thanksgiving	Turkeys
Christmas	Pine Trees
July 4th	Dogs
Valentine's Day	People

TM © ®

Stick man hides in corner.

mermaphrodite

Potato by Architect

Dolphin getting high

self-loathing Voo Doo priest

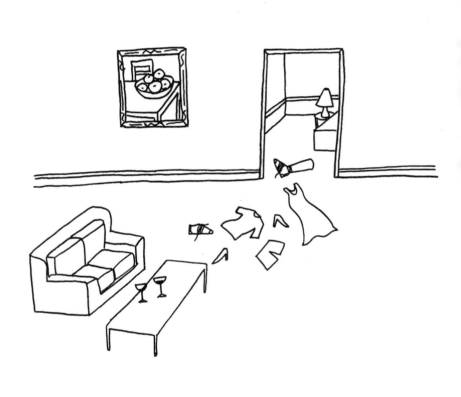

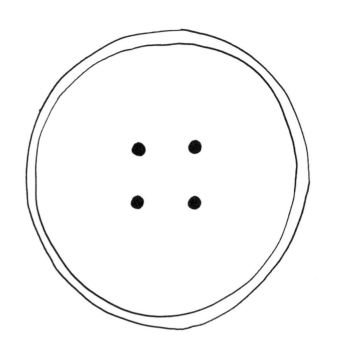

Button

or

Disappointing
pepperoni pizza

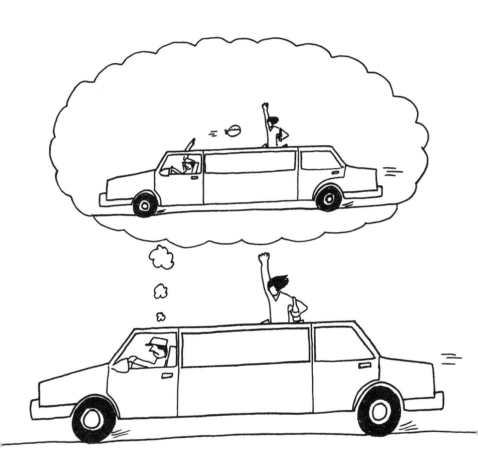

Q: How long have you been sober?

A: 11 years

Then: Loud, supportive applause

Someone shouts: Congratulations! We are proud of you!

Q: How long have you been sober?

A: My whole life

Then: Awkward silence

Someone shouts: Dork!

Concept Cars

Car 1 - Concept: Driver has small genitals

Car 2 - Concept: Driver has lost his hair but made a lot of money

Car 3 - Concept: Driver needs to be noticed a lot

Car 4 - Concept: Tiny genitals

Car 5 - Concept: Driver is going through an age-related crisis and/or genitals thing

When I ~~am reading something and I want to do some highlighting but I~~ don't have a highlighter ~~what I do is~~ I cross out everything that is not important ~~and then that leaves whatever is not crossed out, which is what ends up looking highlighted because it is the only part that has not been "lowlighted." But I'm not sure if this technique really works or if I end up reading all of it anyway because I want to see what's been crossed out.~~

Artist Critic

Mouths

⌣ Friendly

— Attentive

⌣ Smug

⌣ Amused

⌢ Disappointed

╫╫╫ Captured by Weirdo
with Sewing Machine

(Break)

Notches

confused snake

Gardener is lost again

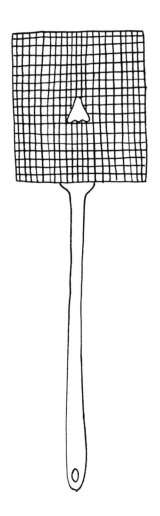

Fly Swatter Designed
to Just Scare the Fly

What kind of Asshole Are You?

- ☐ Kind that cuts you off in traffic
- ☐ Kind that takes too long in line
- ☐ Kind that plays loud bass in his car
- ☐ Kind that goes to the gym all the time
- ☐ Kind you used to date
- ☐ Kind that thinks he knows everything
- ☐ kind that posts comments on Internet
- ☐ kind that shows everyone photos of their kids
- ☐ kind that puts seat back all the way on airplane
- ☐ kind that is a relative
- ☐ Investment banker

Ten Letters

is so true.

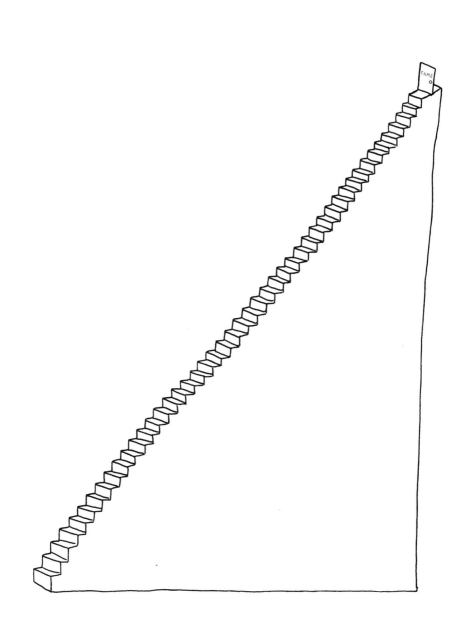

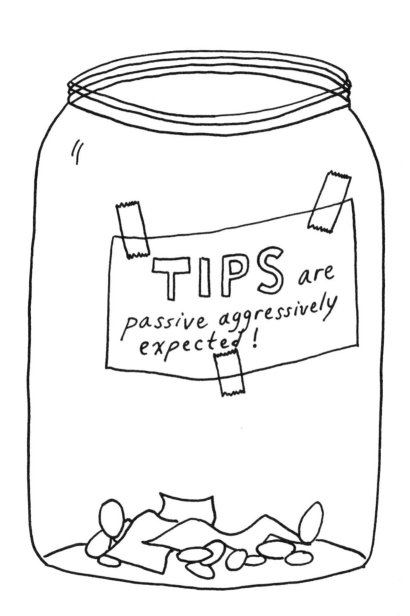

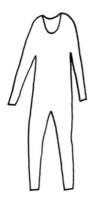

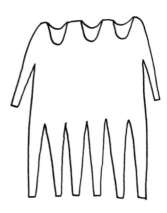

unitard multitard

Friar with facial hair

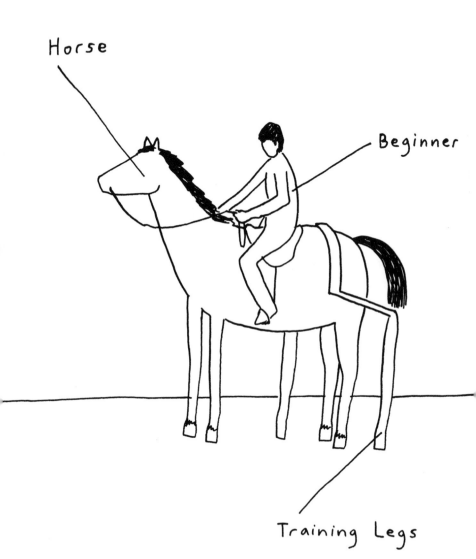

Horse

Beginner

Training Legs

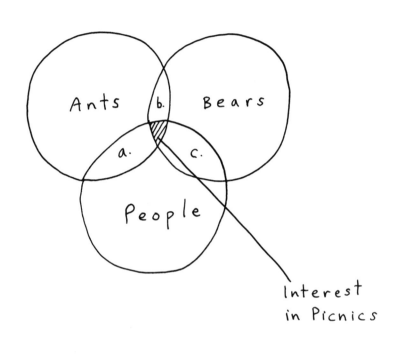

Ants b. Bears

a. c.

People

Interest
in Picnics

a. Hatred of Spiders
b. Attraction to Garbage
c. Employment in Circus

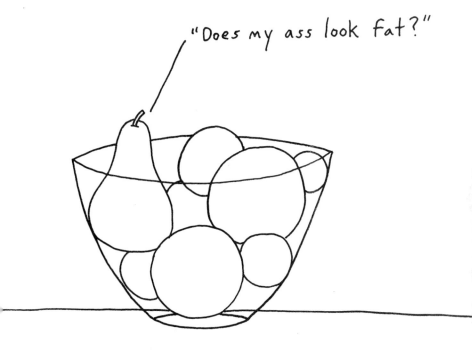

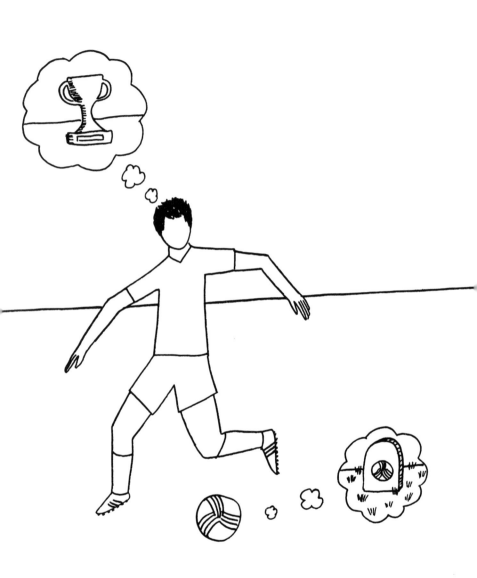

Melted Cheese

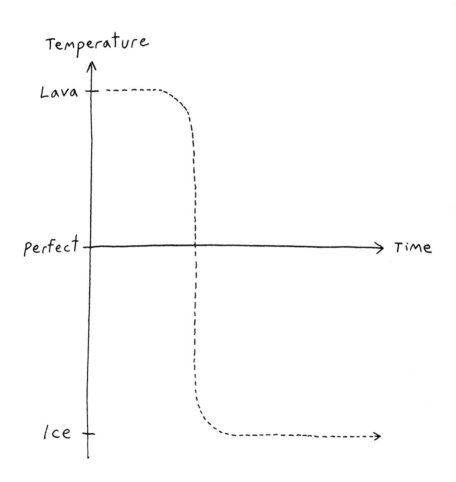

BIRTH CONTROL EFFECTIVENESS

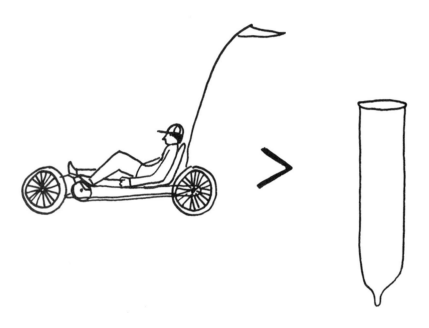

Inappropriate shape for
bowling ball bag

Accordion player tries piano

Depth: 101 Meters

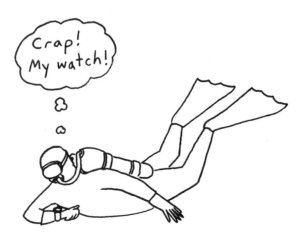

Justice is served > Just ice is served

Beach Body > Beached Body

Sweet Tooth ⟶ Large Ass

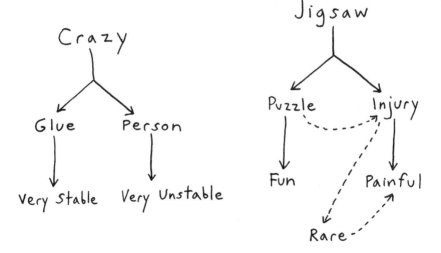

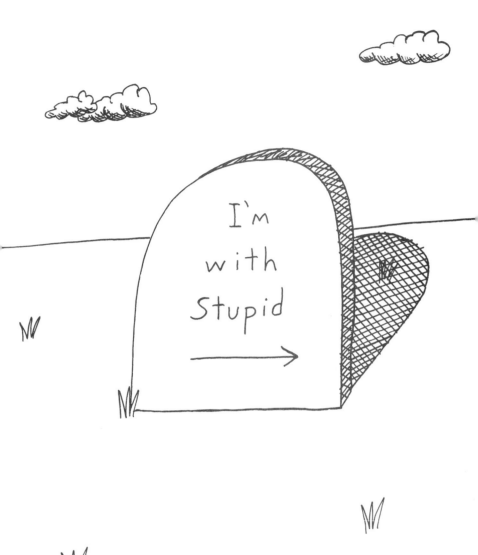

"Watch where you're going, Asshole!"

REALITY

REALITY TV

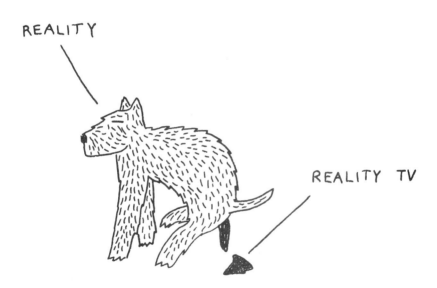

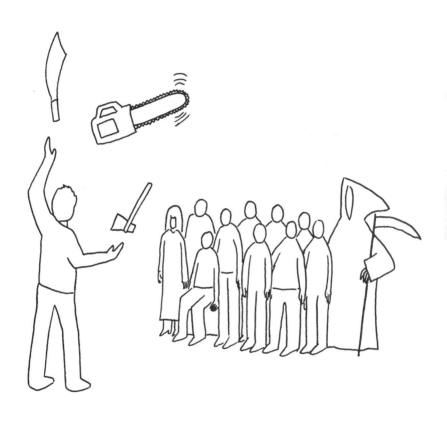

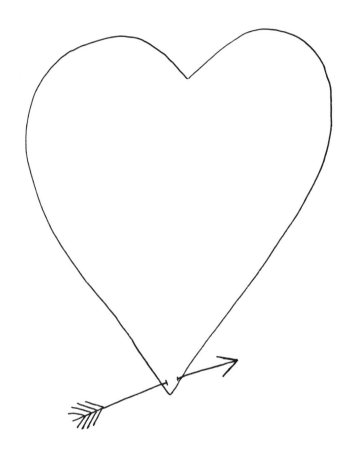

Just liking as a friend

. Certainty

! Excitement

? Wonder

... Intrigue

; Awkward Insecurity
About structure of
Sentence

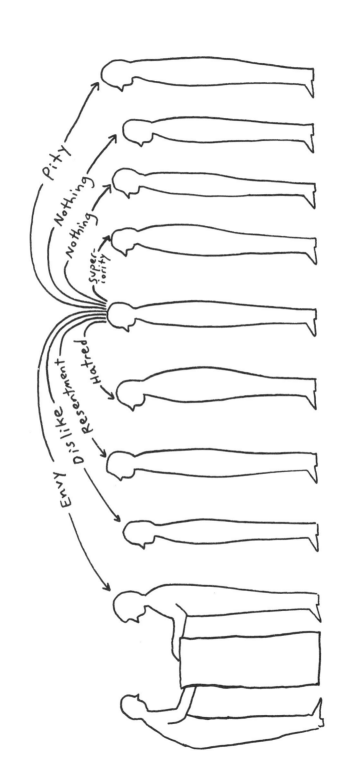

Halloween Costume
Miscommunication

Portrait of the Artist
as a Frustrated Artist

Better shape for
Kraft Singles

Senses

1st Sight

2nd Smell

3rd Taste

4th Touch

5th Hearing

6th ESP

7th That your fly
 is down

"So... when the monster caught you
your boyfriend must have been
pretty upset... I mean, if you, um
have a boyfriend. Uh, so... do you
have a, um, boyfriend or...?"

Some men are born great.
Others have greatness thrust
upon them.*

* Also true when you replace
"great" with "bald".

Activities*

Running through sprinklers

Rolling down a hill

Sleeping outside

Climbing a tree

Eating snails

Skydiving

Sex

* more fun if being done because you planned to rather than all of a sudden because of a mistake.

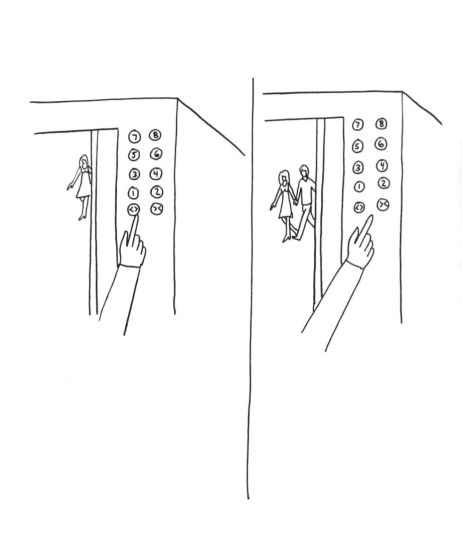

Personal

Strong ┤ ▉ ▉
 work Relax
 (Ethic)

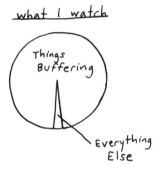

Things Buffering

Everything Else

* * * * * *
Password

...... Mood
—·—· Weight
⌇⌇⌇⌇ Flexibility
——— Name

Feelings For:

Chocolate	Love
Cauliflower	Hate
Hot Sauce	Respect
Tomato	Like as Friend
Peanuts	Fear*

* Severe Allergy

Data

Ranking of Elementary School Teachers

Rank	Grade
1st	6th
2nd	1st
3rd	3rd
4th	4th
5th	5th
6th	2nd

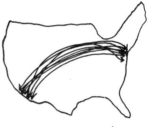

Career Trajectory

Birth •————↑————• Death

Important Lunch Meeting

Basic Info

Hair : Yes

Eyes : Yes

Sex : Yes

Fight History

Me : 0

Kitchen Cabinets : 17

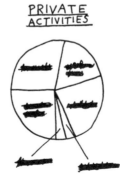

PRIVATE ACTIVITIES

Interest In Drawing Graphs

TIME

Man abducted by tiny aliens

And so began the most
passionate love affair
Passaic, New Jersey had
ever known.

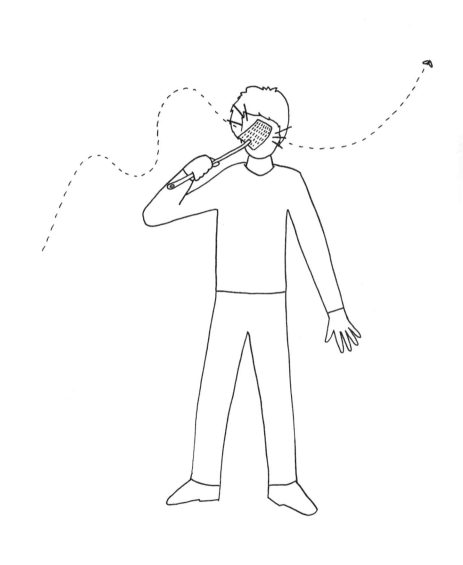

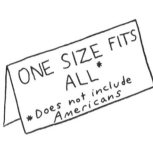

ONE SIZE FITS ALL
*Does not include Americans

WELCOME to NEW JERSEY (SORRY)

Please wait to Read This Sign

God Bless This House but only while we live in it.

BEWARE OF DOGGY

ALL YOU SHOULD EAT $2.99

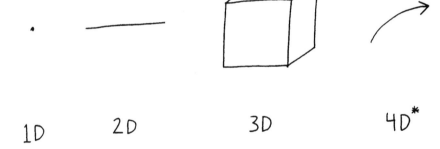

1D 2D 3D 4D*

✳ During page turning

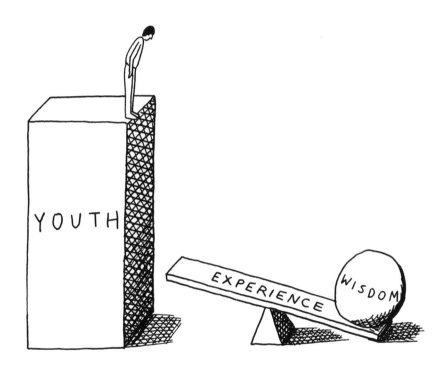

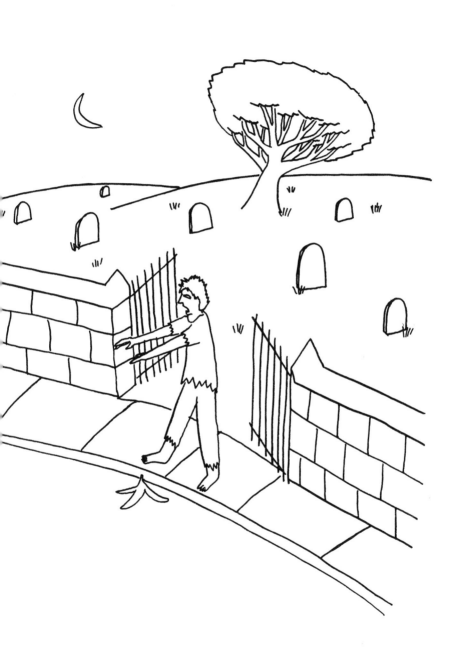

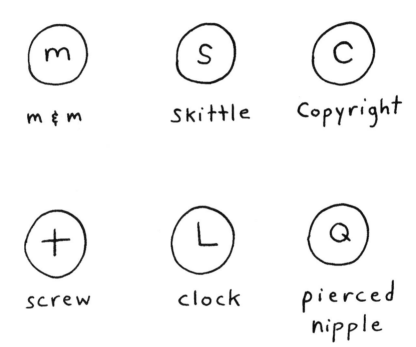

m & m

skittle

Copyright

screw

clock

pierced
nipple

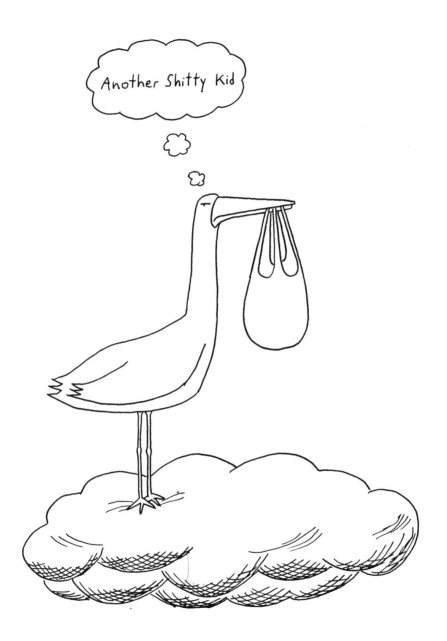

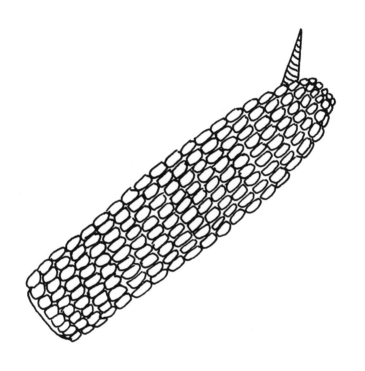

cornicorn

unfinished drawing of porcupine
in grassy field during rainstorm

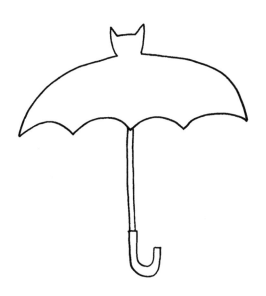

Batman's Umbrella

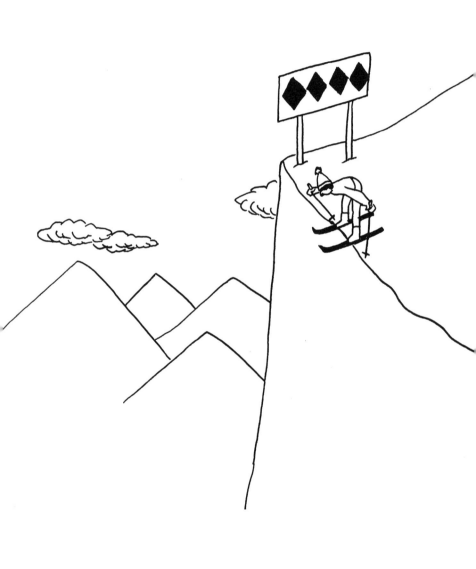

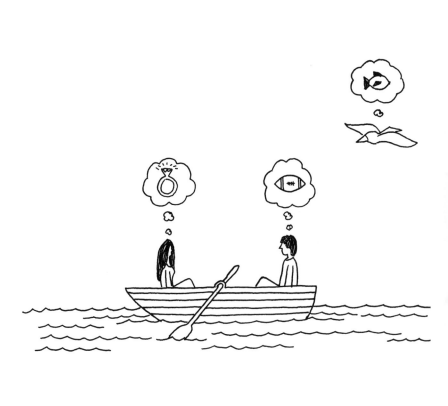

Equations

$(\text{Darkness} \times \text{Driving}) + \text{Cat} = \text{Speed Bump}$

$\text{Lip Ring} = \text{Lip} + \text{Hole} + \text{Ring} - \text{Good Judgment}$

$\text{July 4} = \text{Fingers} - 1$

$\text{Olive Garden} = \text{Italian Food} - \text{Italian} - \text{Food}$

$\text{Spray Tan} = (\text{Vanity} + \text{Stupidity}) \text{Aerosol}$

$\text{Rabbit} + \text{Rabbit} = 60 \text{ Rabbits}$

$\text{Coca Cola} + \text{Mouth} = \text{Mouth} - \text{Teeth}$

$\text{Man} + \text{Waterskis} + \text{Boat} - \text{Balance} = \dfrac{\text{Face}}{2}$

$\dfrac{(\text{TV} + \text{HD}) \text{ Flat Screen} + \text{HD}}{\text{Time}} = (\text{Man} + \text{Fat})^{\text{Lazy}}$

$\text{"And} + \text{Much} + \text{More"} = \text{Not much more At All}$

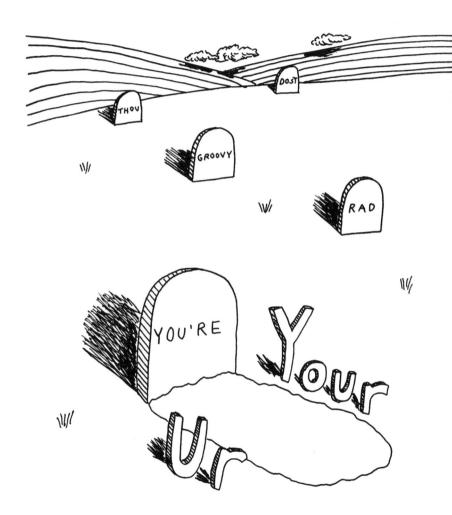

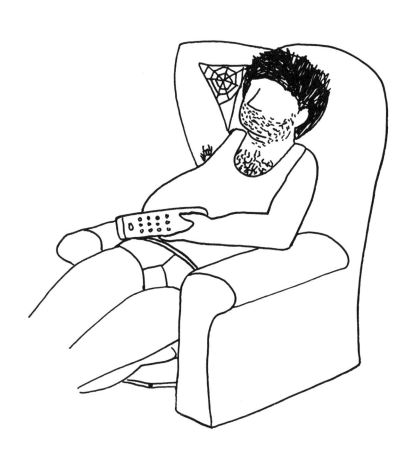

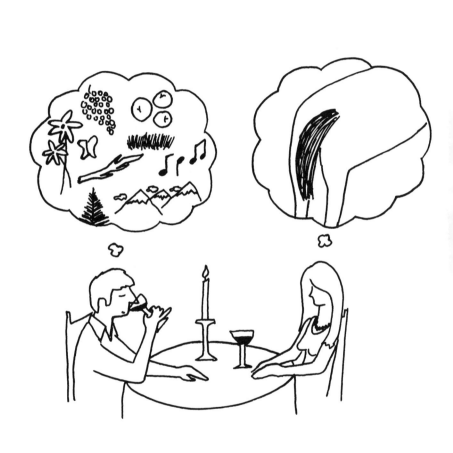

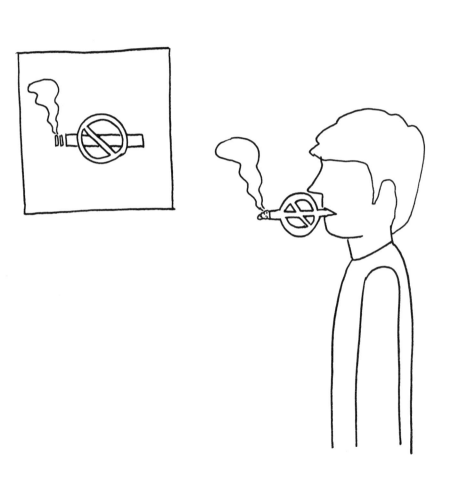

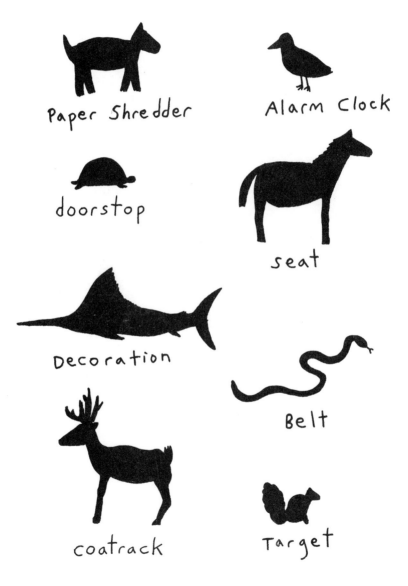

Paper Shredder

Alarm Clock

doorstop

seat

Decoration

Belt

coatrack

Target

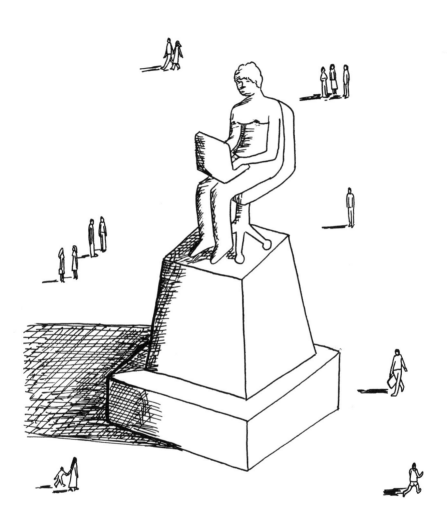

"The Blogger"

Lovers' Lollipop

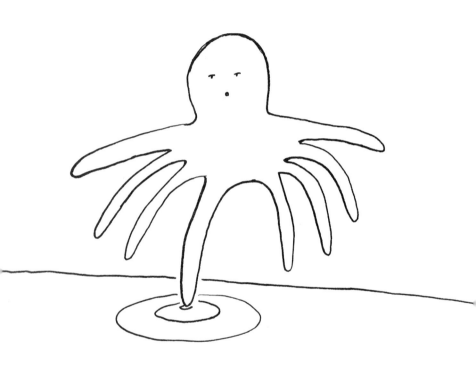

octopus testing water

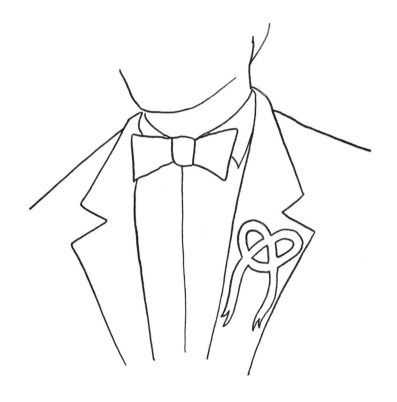

Ribbon worn in support
of pretzels

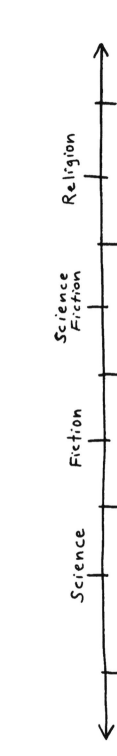

megapixel

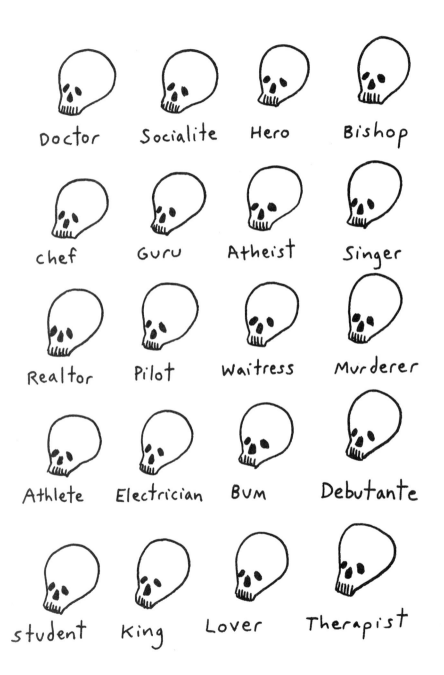

Doctor Socialite Hero Bishop

chef Guru Atheist Singer

Realtor Pilot Waitress Murderer

Athlete Electrician Bum Debutante

student King Lover Therapist

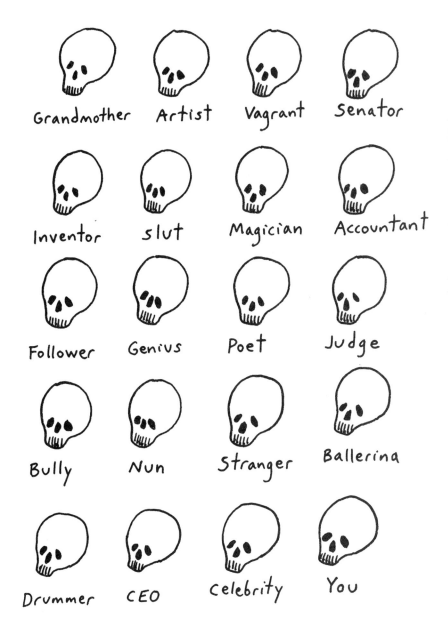

Fear

Deadlines

Procrastination

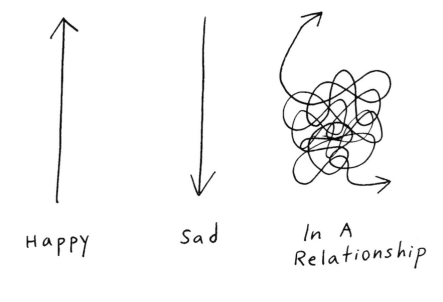

Happy

Sad

In A
Relationship

Unpopular Luggage Design

Animals

Looks Ugly , Tastes Delicious A	Looks Cute , Tastes Delicious B
Looks Ugly , Tastes Terrible C	Looks Cute , Tastes Terrible D

A = Food

B = Food (but only in emergency)

C = Target

D = Pet

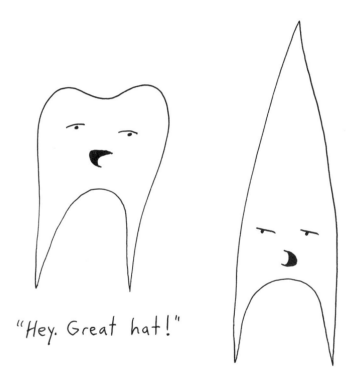

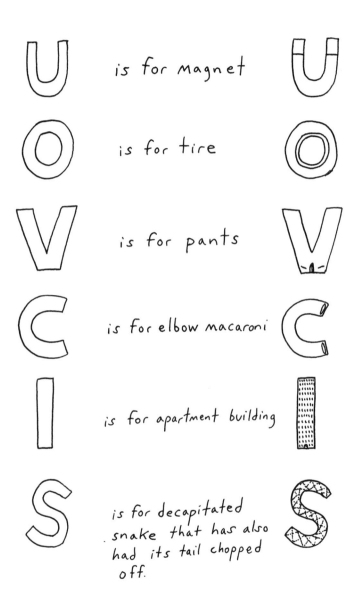

is for magnet

is for tire

is for pants

is for elbow macaroni

is for apartment building

is for decapitated snake that has also had its tail chopped off.

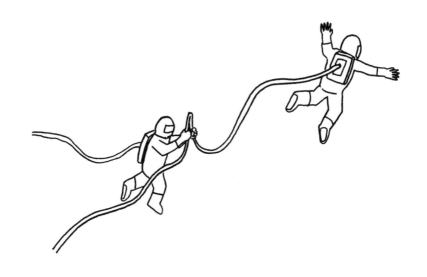

Space Prank

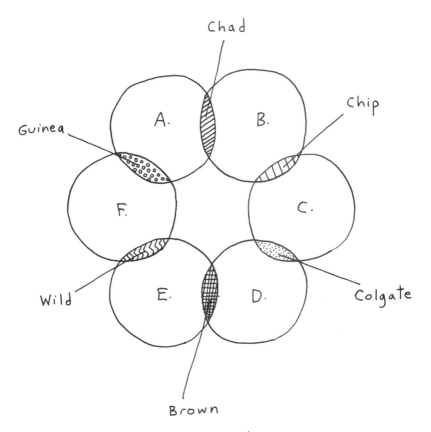

Chad

Chip

Guinea

Colgate

Wild

Brown

A. African Countries
B. Preppy Guy Names
C. Things that Go in Mouth
D. Colleges
E. Rice Types
F. Kinds of Pigs

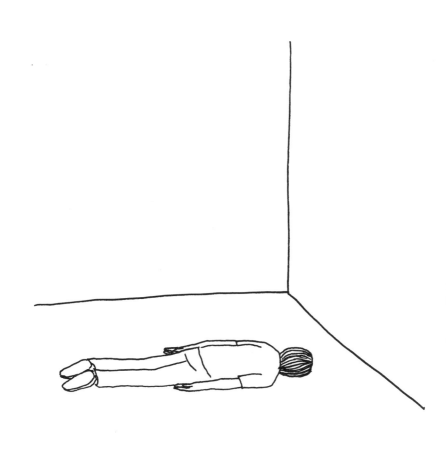

minimalist takes nap

Corrections

Boxing ~~Gloves~~ → (Mittens)

Super ^ Shuttle
(Slow)

~~Fencing~~ → (Sword Fighting)

Talent Show ^ (?)

(Tug) of (War)

~~Silly~~ ^ String (Inconsiderate)

Volunteer ^ Firefighter ^
(in advance) (who apparently can't just show up and pitch in)

"Blow it out your ass."

"Honey, you might want to come in here. There is a gigantic, three-dimensional person in our living room right now."

Man takes pet fish
for walk/swim

"Give me an A!"

"Give me an A!" shouts man to crowd.
"A!" shouts crowd back to man.

"Give me an A!" says man to stranger on street.
"Piss off," responds stranger.

"Give me an A!" demands student.
"Do the work and we'll see," explains teacher.

"Give me an A!" says guy changing letters on
sign to coworker standing at bottom of
ladder next to bin of letters.
"Here you go," responds coworker, handing him
an A.

"Give me an A!" says parrot owner to parrot.
No response from parrot.

Grief-stricken

Trying out
Glow-in-the-dark
Item

Hand Motions

"Can we get the check please?"

"Rest in Peace"

"Okay, come on — speed it up."

conductor

"Get out!"

"Don't do that again."

counting five things

"Go straight, make a left and then it's on your right."

"I'm talking to you!"

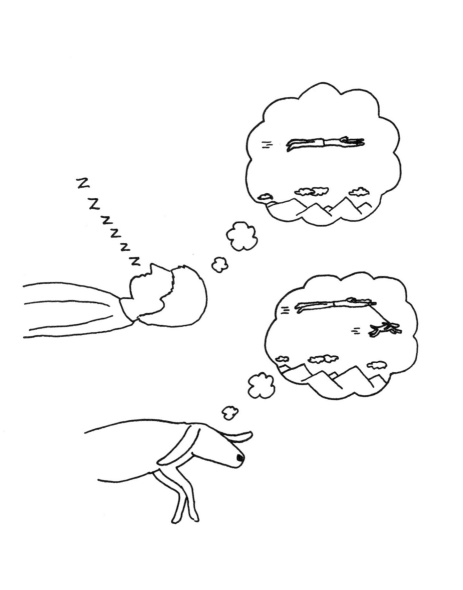

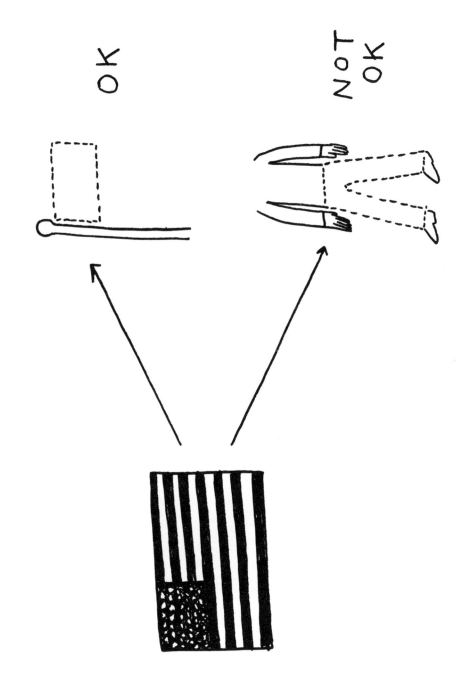

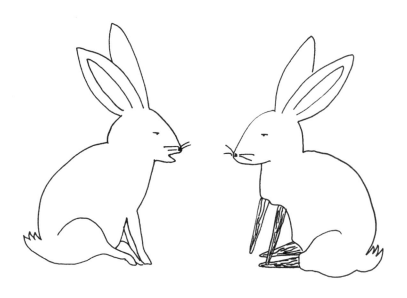

"So why do they call you 'Lucky'?"

~~Per~~fumes

Identity

Repe*titi*ous

to/get/her

li~~tter~~

long ^er

Unaltered

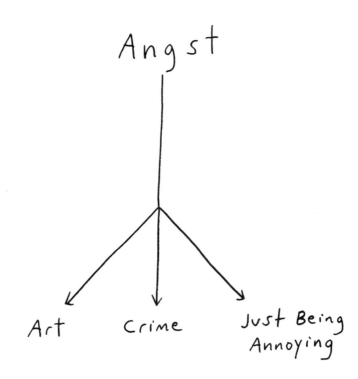

The Human Condition

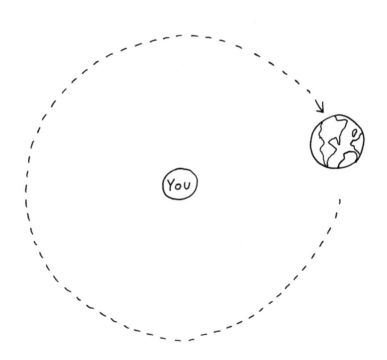

Economics

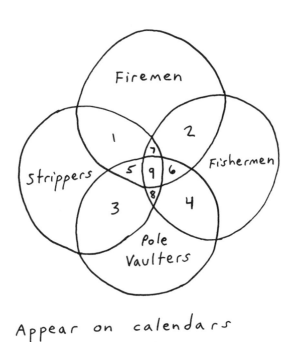

1 Appear on calendars
2 Sometimes get burns
3 Frequently go upside down
4 Involved with body flopping
5 Don't kill fish
6 Keep clothes on
7 Often get wet
8 Wearing a helmet looks weird
9 Work with poles

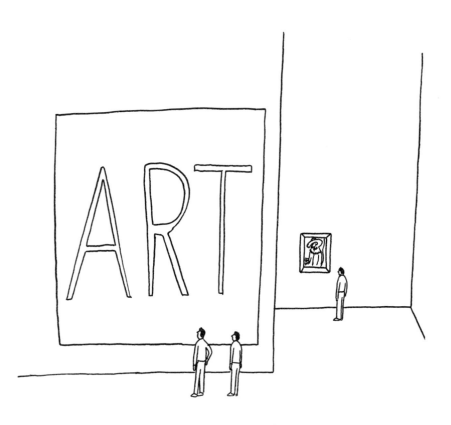

"I don't get it."

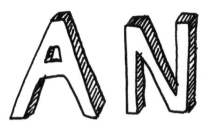

Thanks

Race

Rachael

Bee

Daniel

Pippa

Appendix of Deleted
Drawings

Now point
your face
somewhere
else

please
ignore
this page.